NEW ART DECO ALPHABETS

BY MARCIA LOEB

DOVER
PUBLICATIONS INC.
NEW YORK

Published in Canada by General Publishing Company, Ltd., 30 Lesmill Road, Don Mills, Toronto, Ontario.
Published in the United Kingdom by Constable and Company, Ltd.

New Art Deco Alphabets is a new work, first published by Dover Publications, Inc., in 1975.

DOVER *Pictorial Archive* SERIES

International Standard Book Number: 0-486-23149-6
Library of Congress Catalog Card Number: 74-29015

Manufactured in the United States of America
Dover Publications, Inc.
31 East 2nd Street
Mineola, N.Y. 11501

Publisher's Note

When Marcia Loeb produced her first book, *Art Deco Designs and Motifs,* in 1972, the rediscovery of this vibrant art movement of the Twenties and Thirties was just beginning. It has now blossomed forth as one of the major reincarnations in art history: we are not merely using Art Deco, we are reliving it.

Miss Loeb's successful earlier book included one spectacular alphabet that created a demand for a bookful. Here, then, are 38 brand-new complete upper-case Art Deco alphabets, invented specially for this book. Five of the alphabets include numbers as well as letters. 28 of them have names suggestive of their character. Sometimes the letters forming these names have been taken out of their normal alphabetic sequence, but elsewhere the names are formed from letters that have been enlarged or reduced (which also demonstrates their capabilities of transformation).

It is needless to suggest all the uses of these fanciful and highly variegated sets of letters, which run the entire gamut from discreetness and dignity to fun and flamboyancy within the Art Deco tradition.

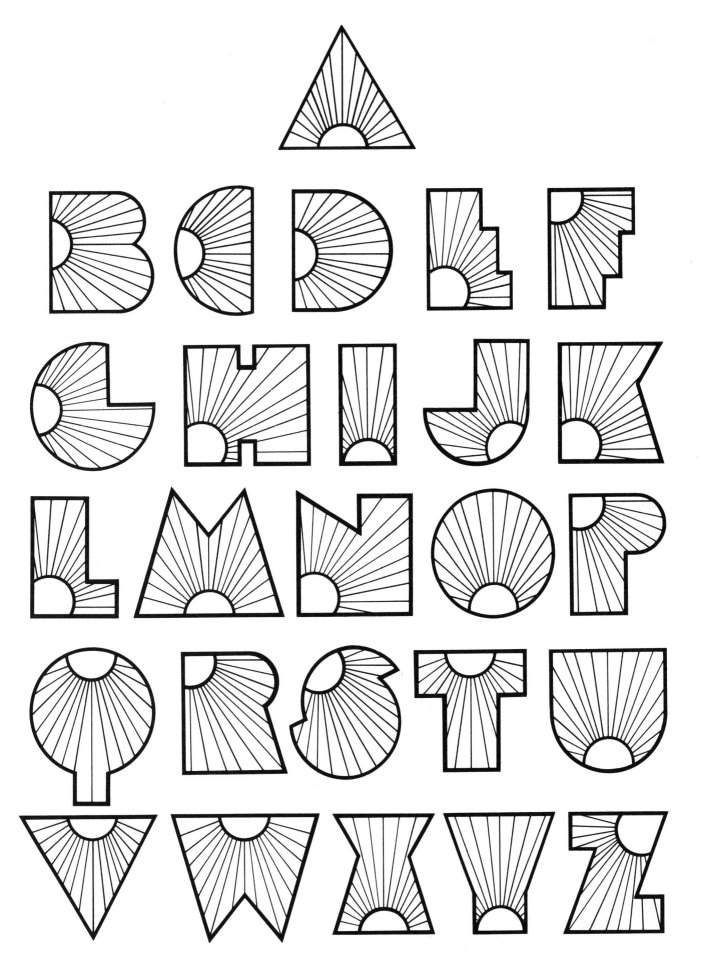

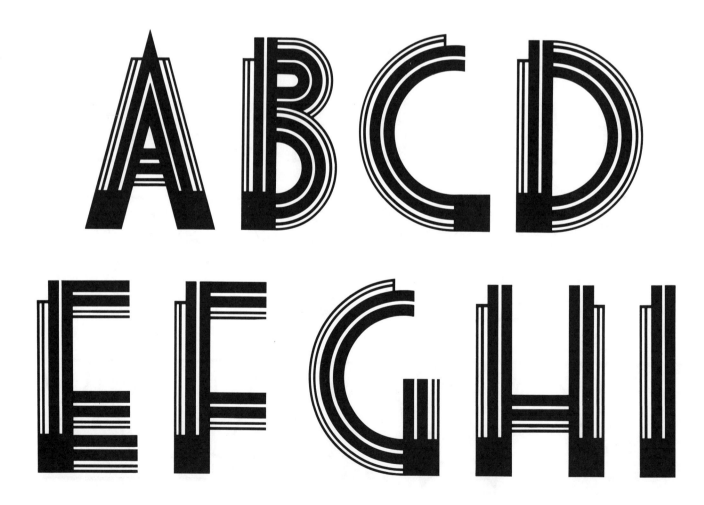

2

JKLM
NOPQ
RSTU
VWXYZ

ABC
DEFGH
IKMN
OQR

4

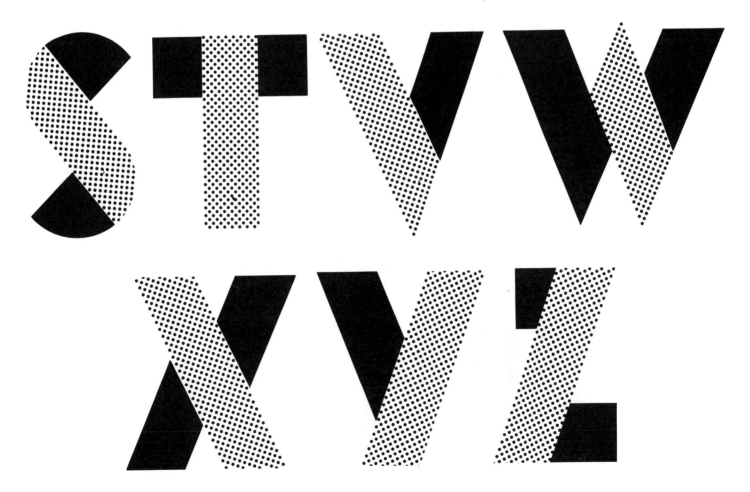

JULEP
STVW
XYZ

5

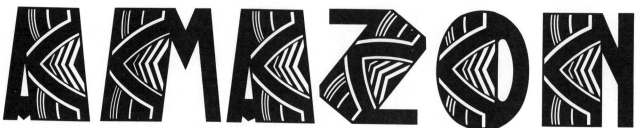

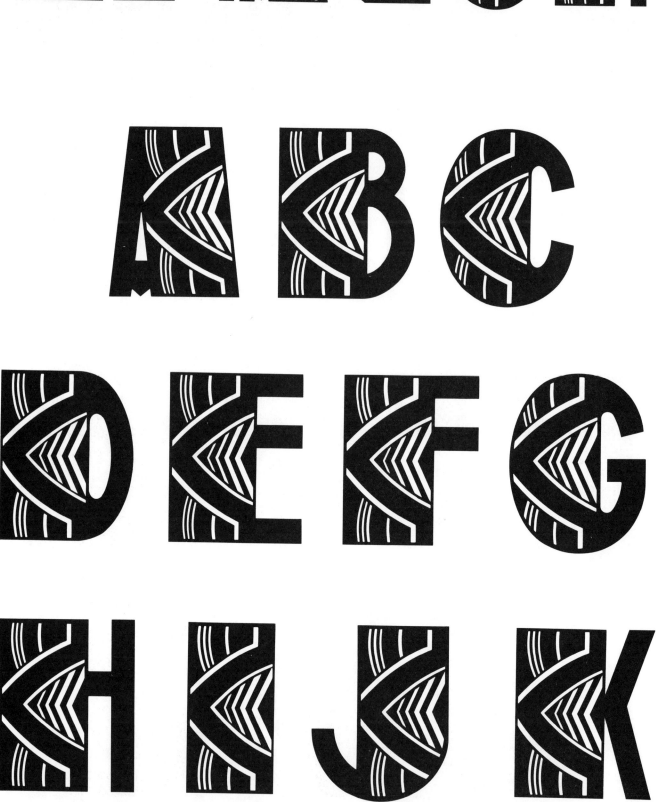

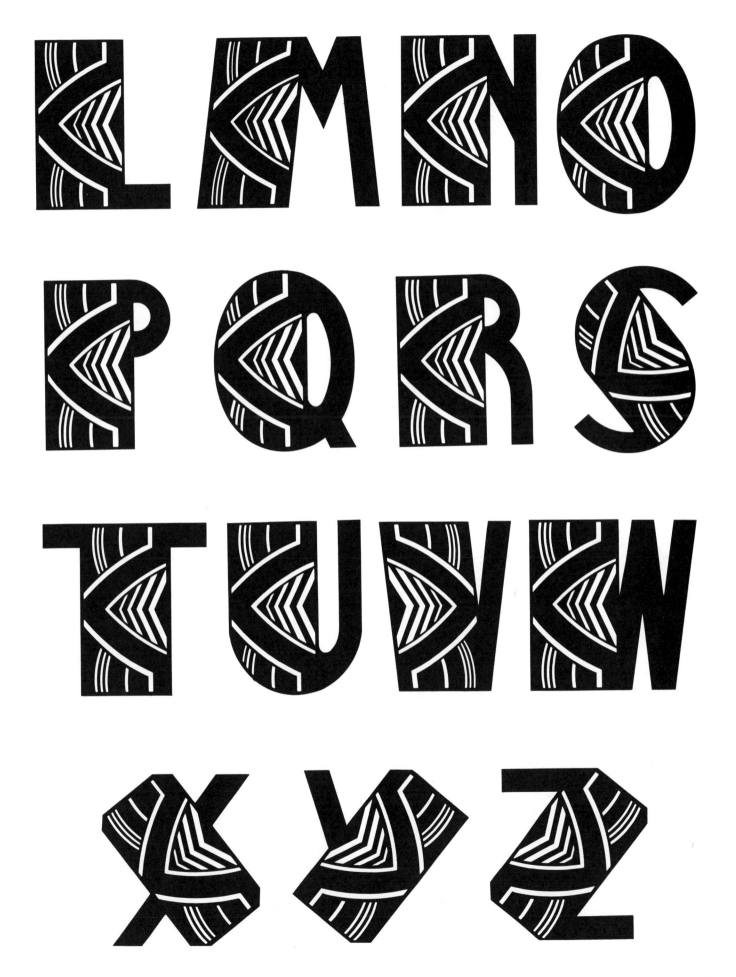

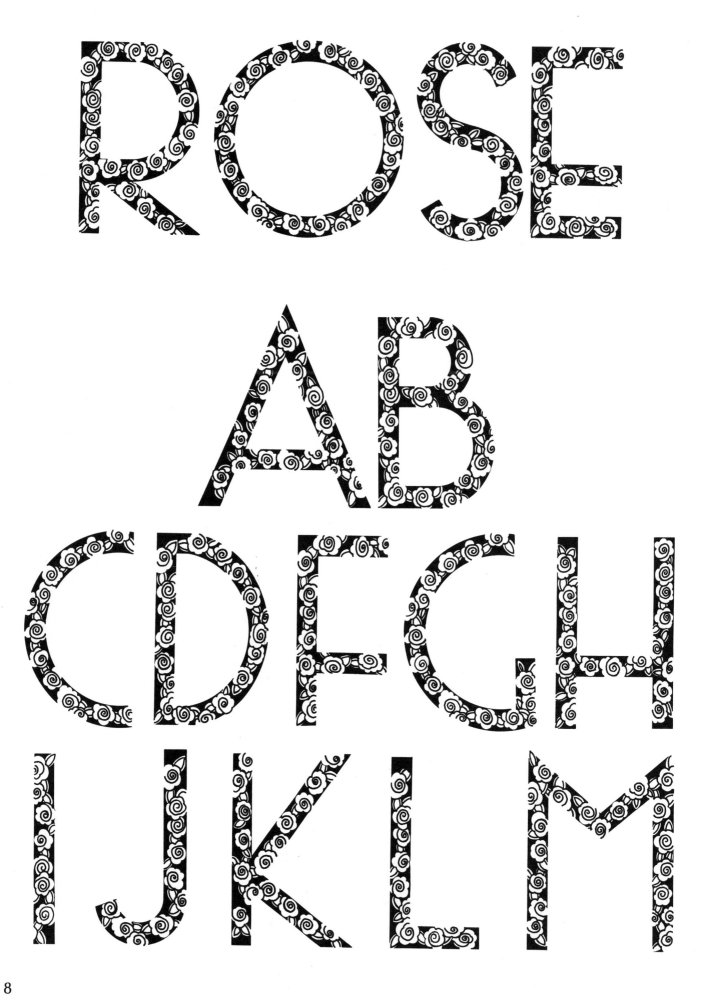

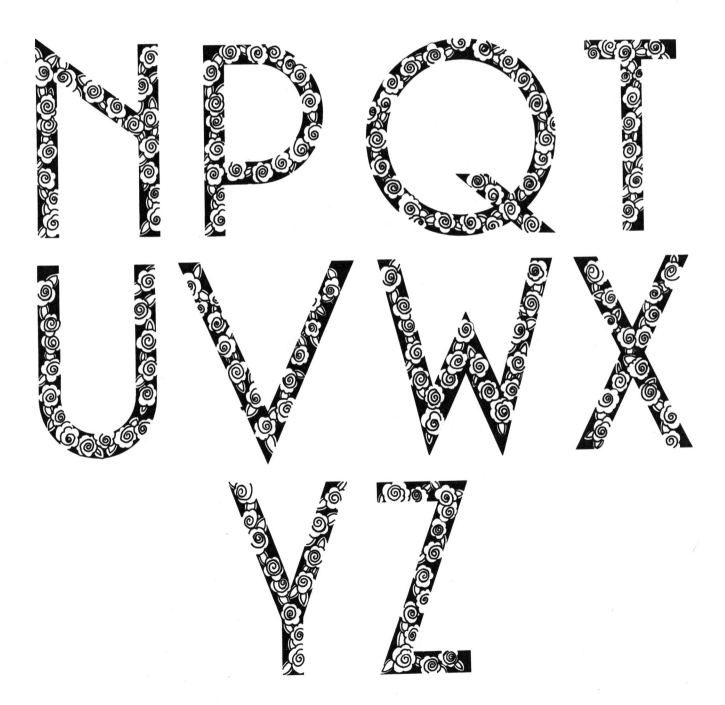

9

ZIG

B C D E

F H J K

L M N

ZABU

OPPQR

STUV

WXY

11

mah·jong

12345
67890

abcdef
ghijklm
nopqrst
uvwxyz

BOOGIE

A B C
D E F G
H I J K

14

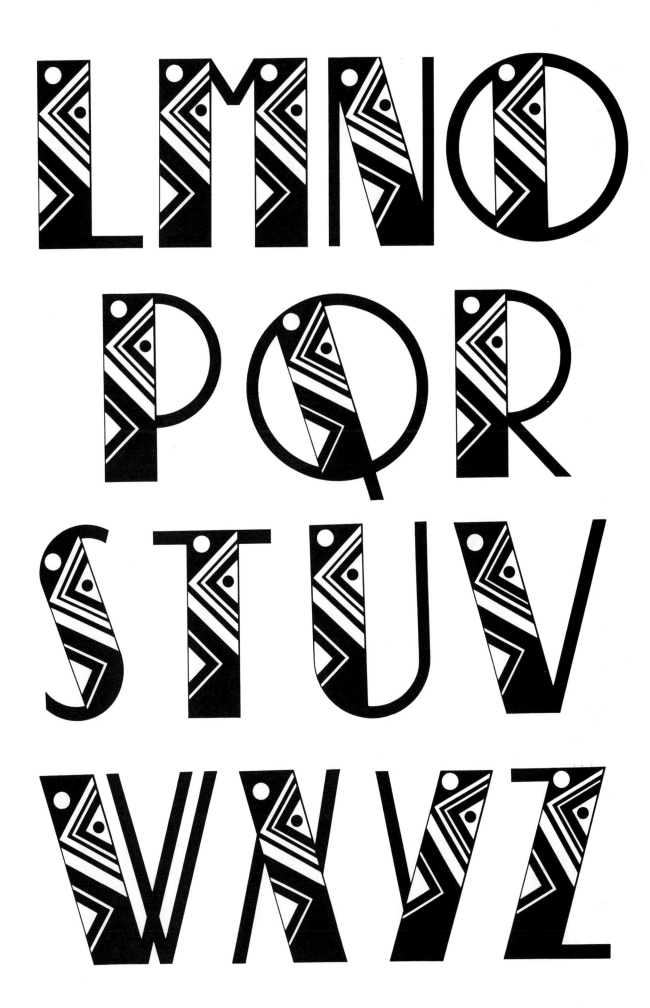

STAR

A B C D E F
G H I J K L M
N O P Q R

DUST

STUVWX
YZ1234
567890

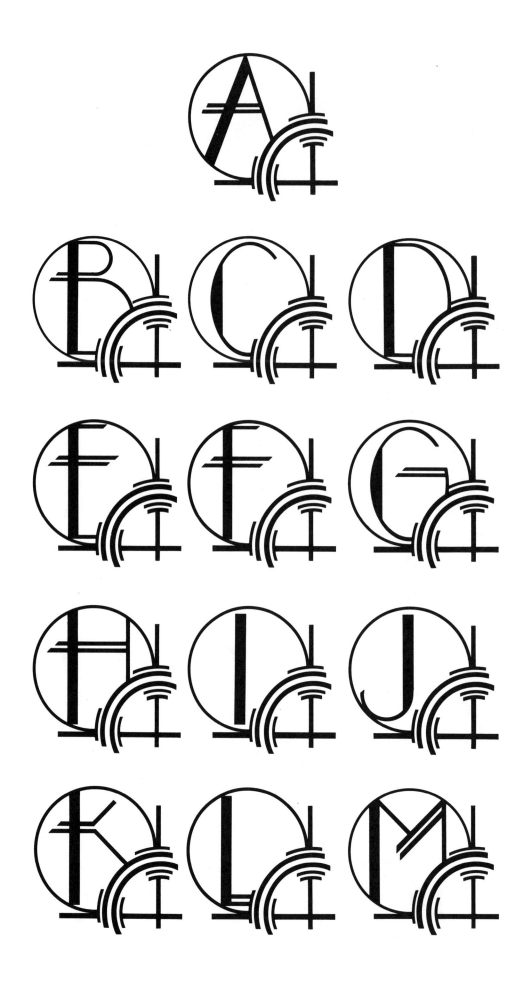

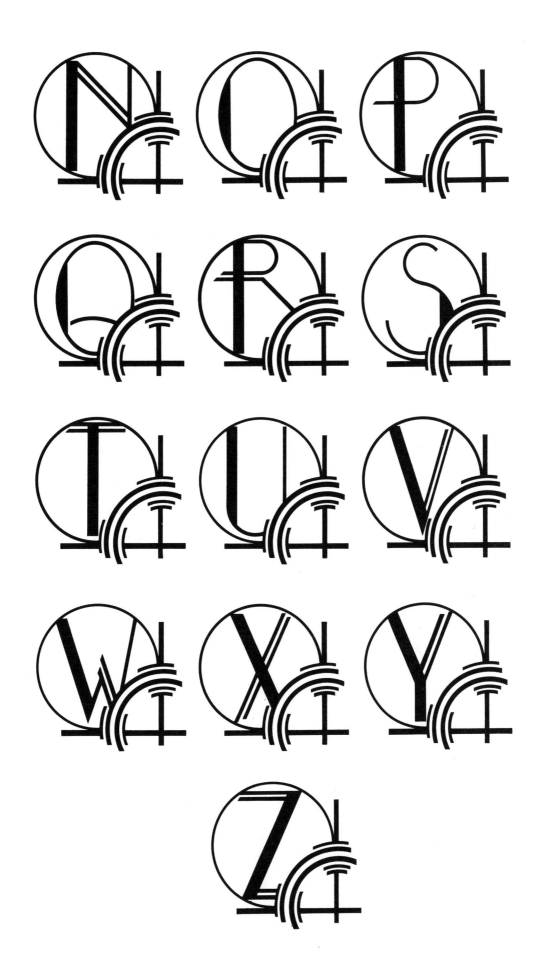

SAMBA
ABC
DEFG
HIJK

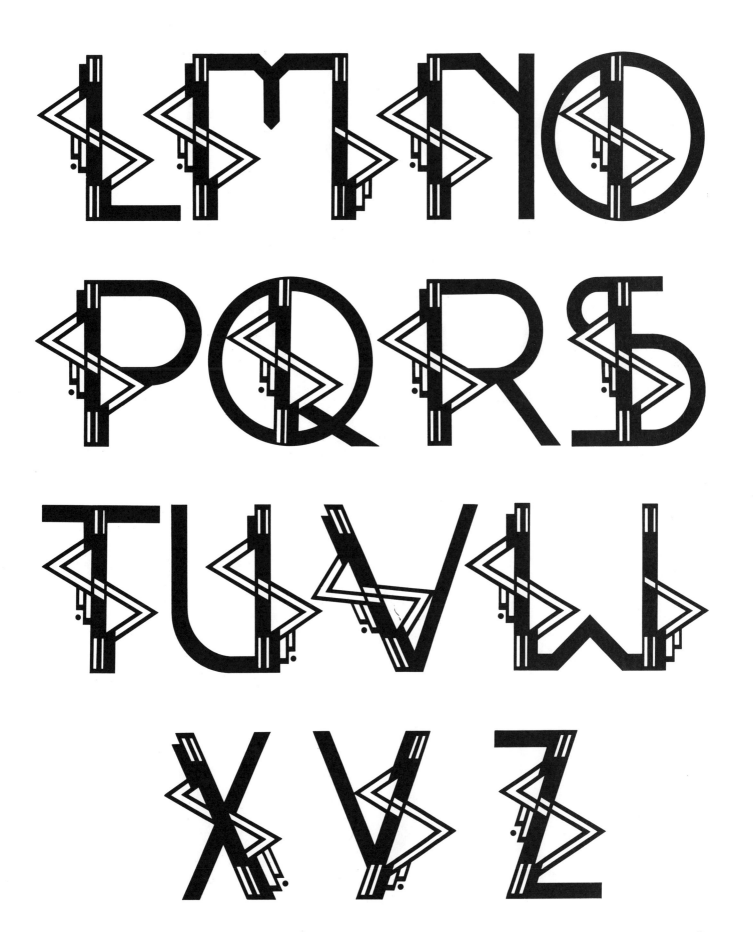

21

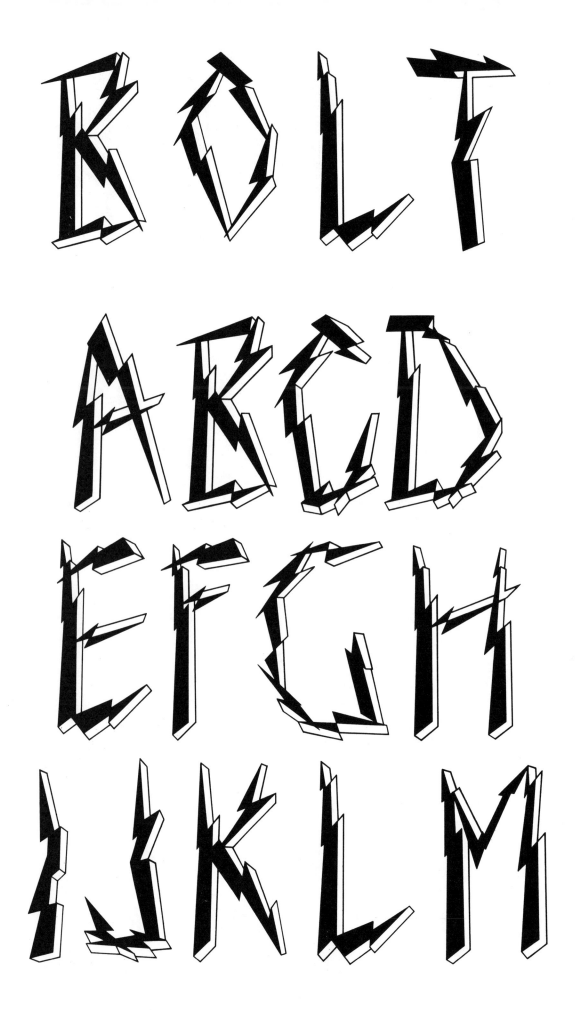

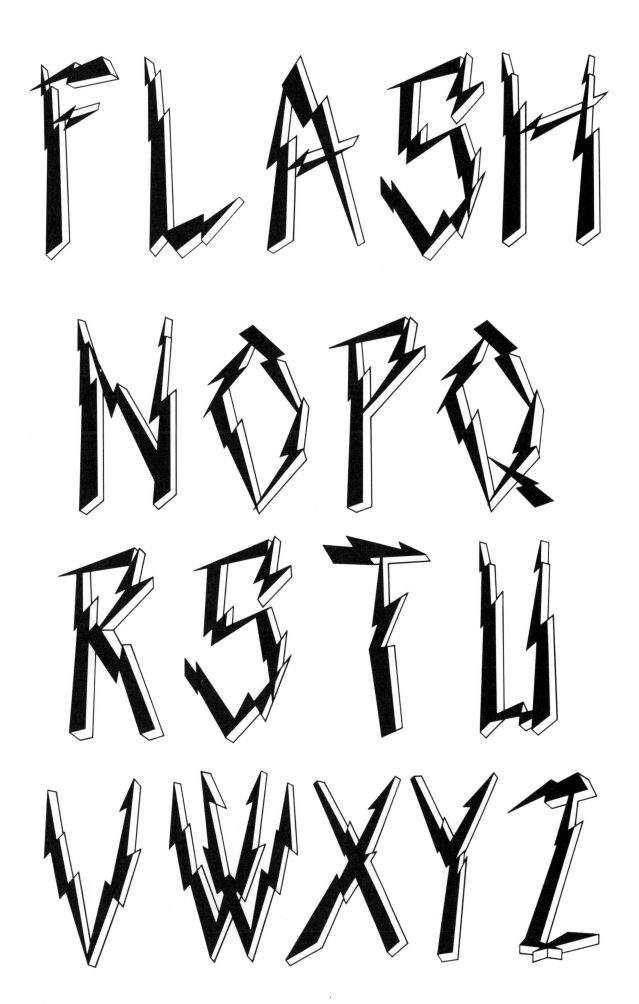

A B C
D F G H
J K M N

ELITE

OPQ

RSUV

WXYZ

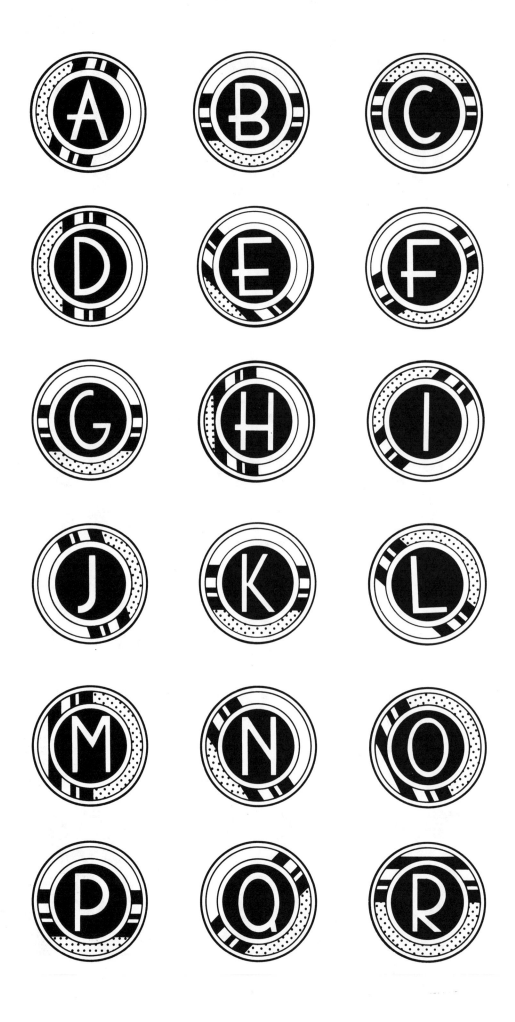

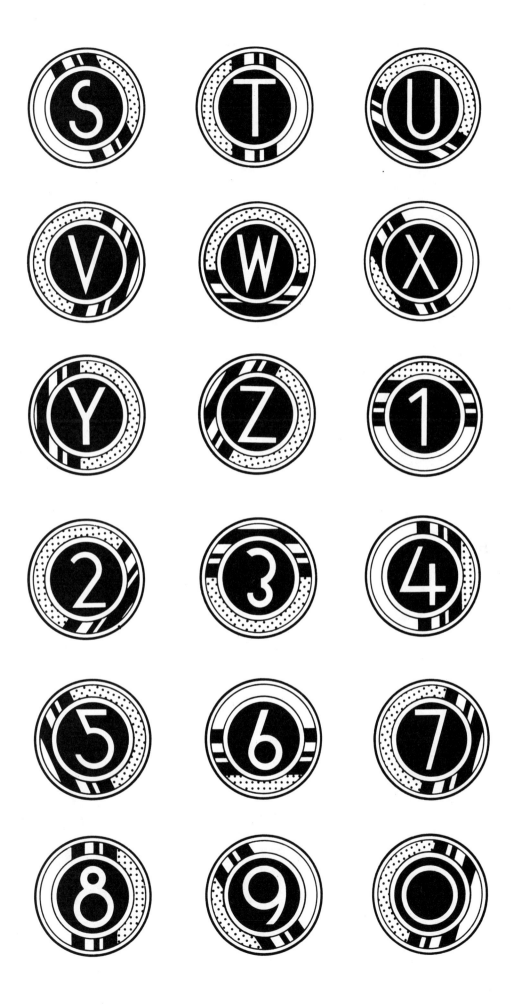

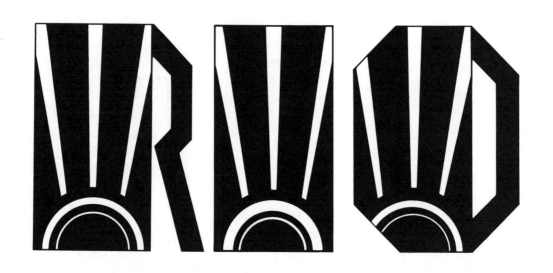

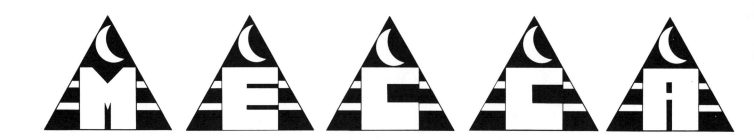

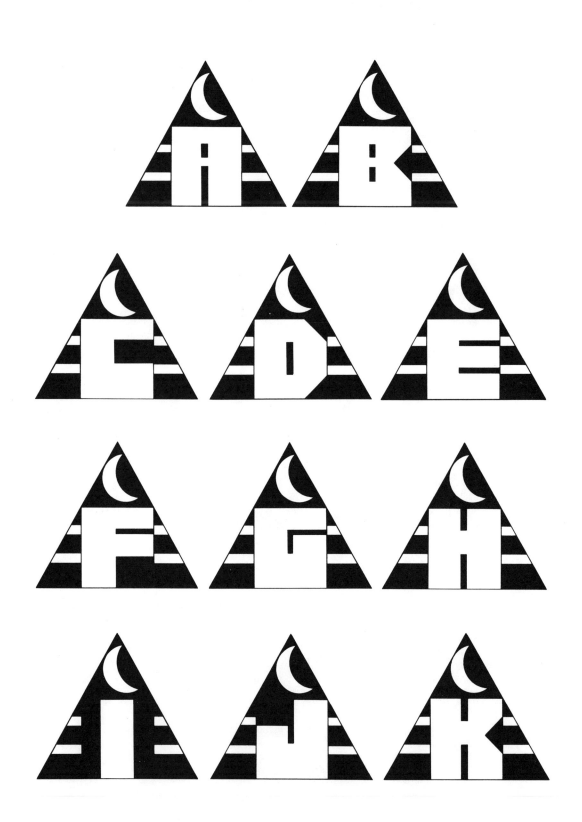

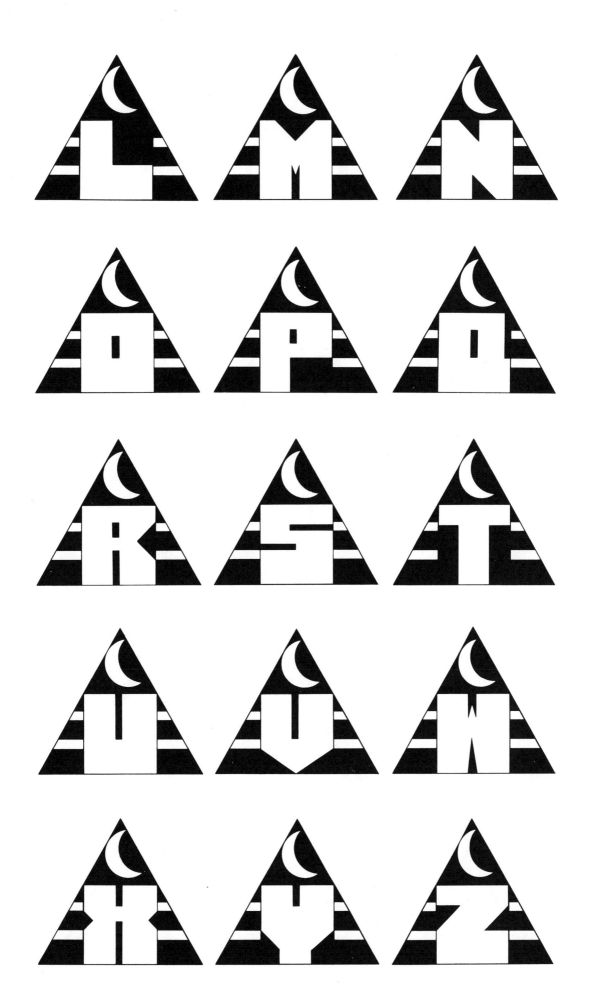

INCA

A B C

D E F G

H I J K

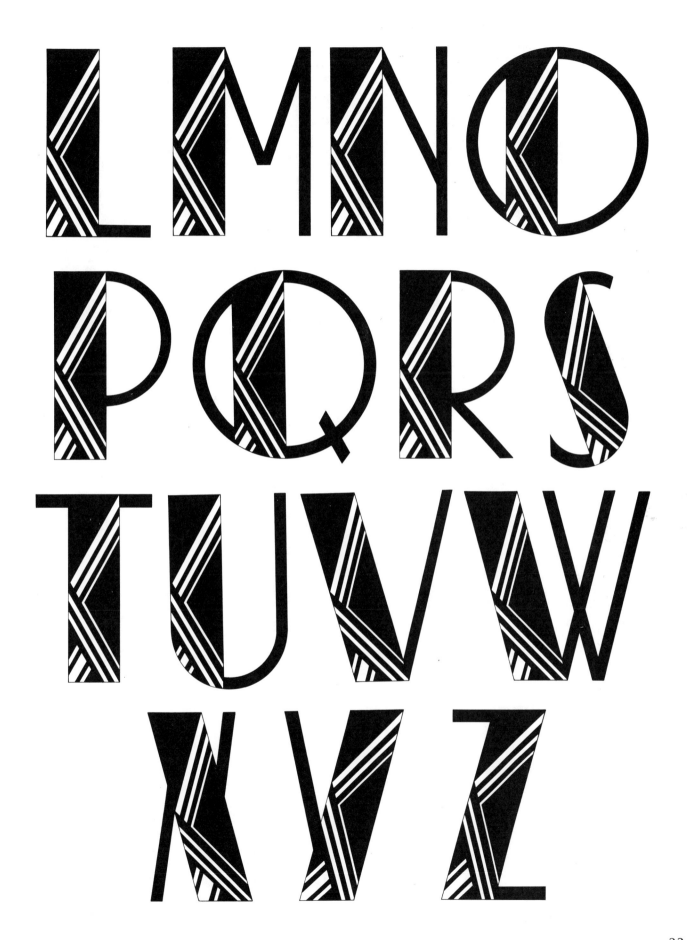

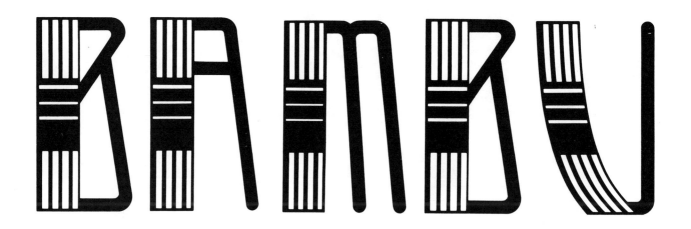

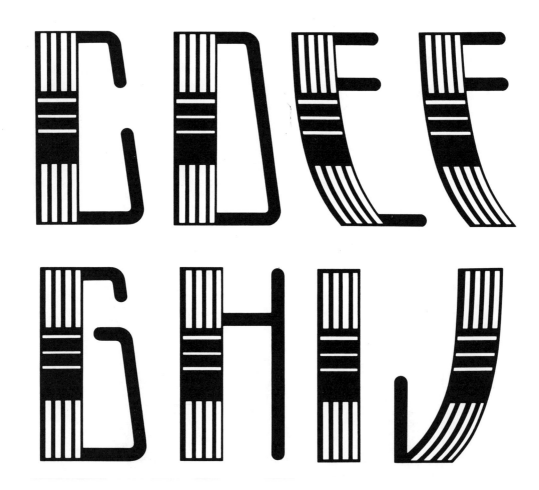

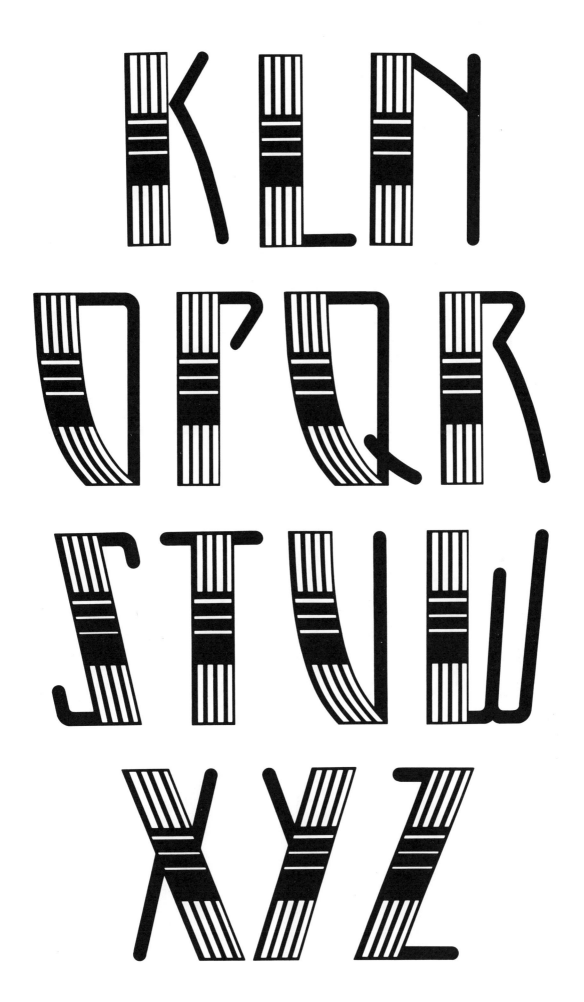

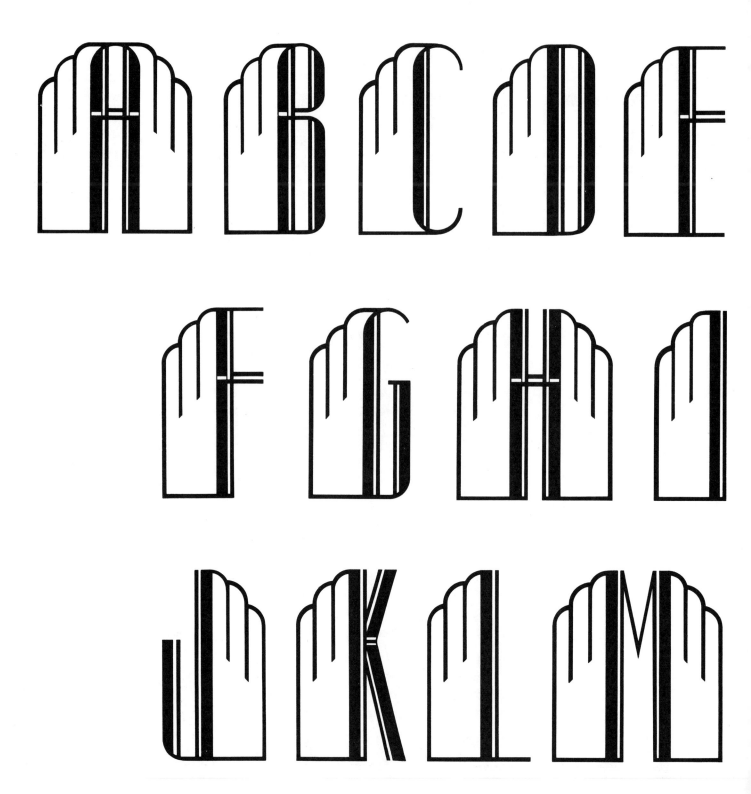

36

CLAUDE
NOPQR
GTUV
WXYZ

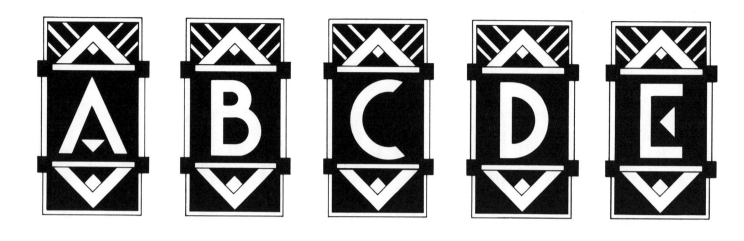

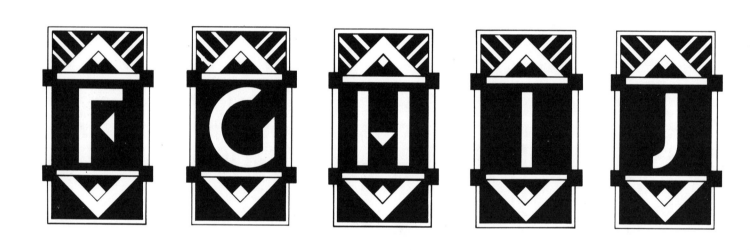

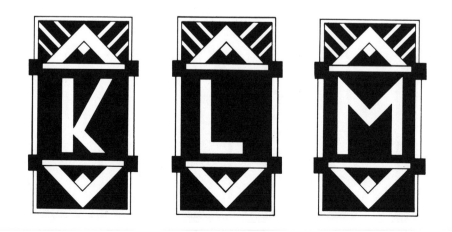

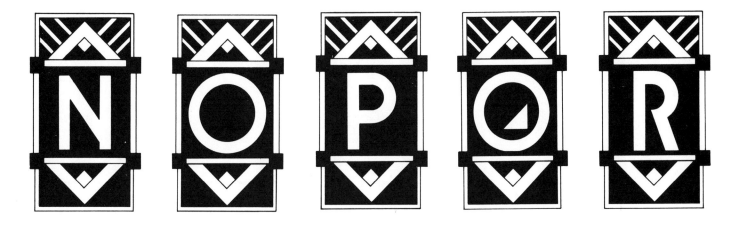

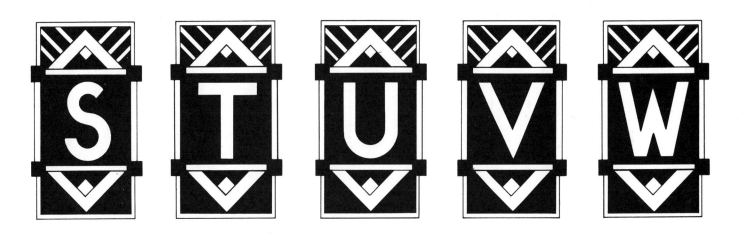

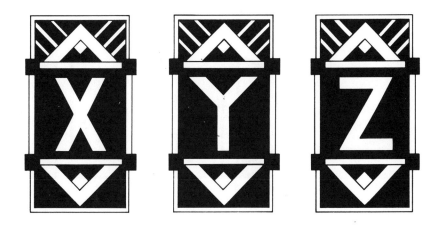

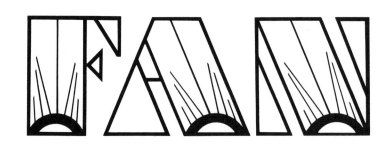

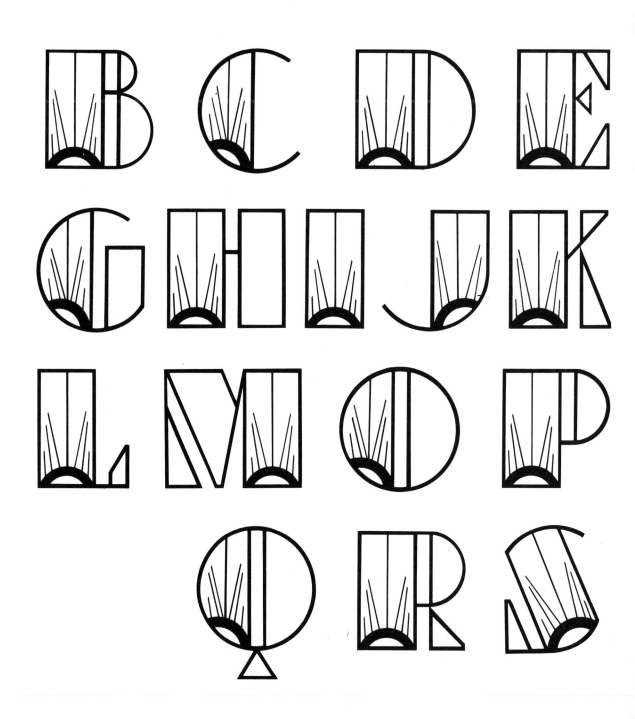

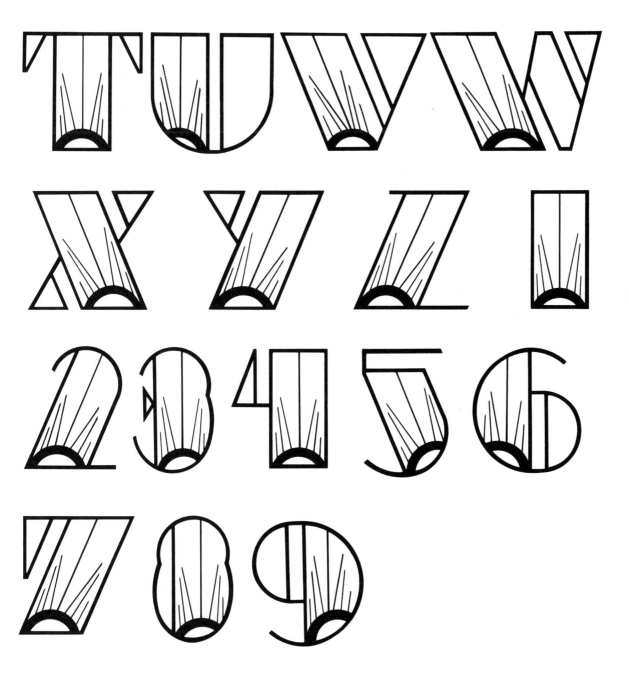

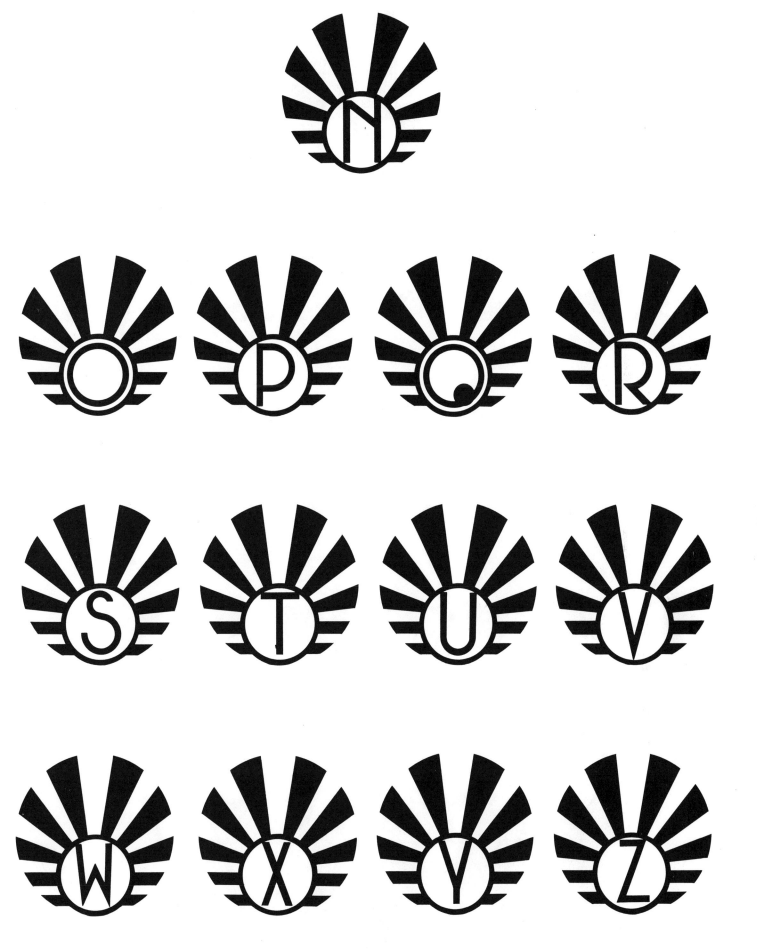

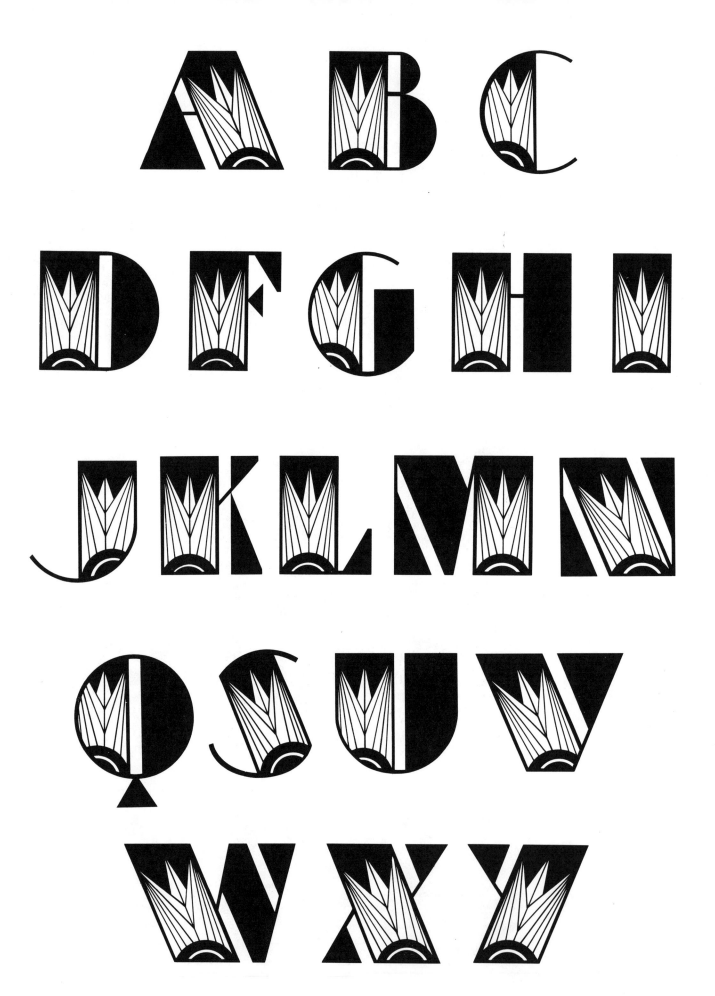

TROPEZ

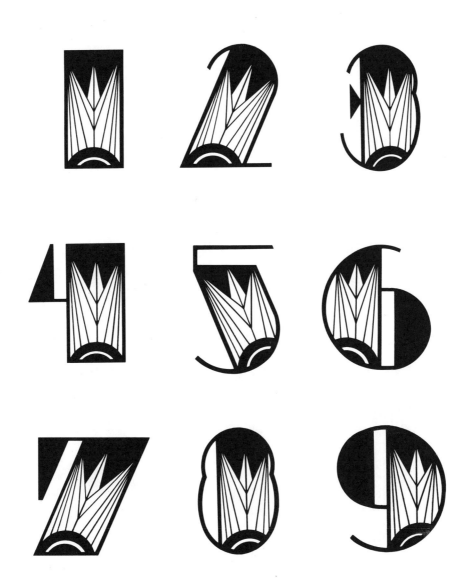

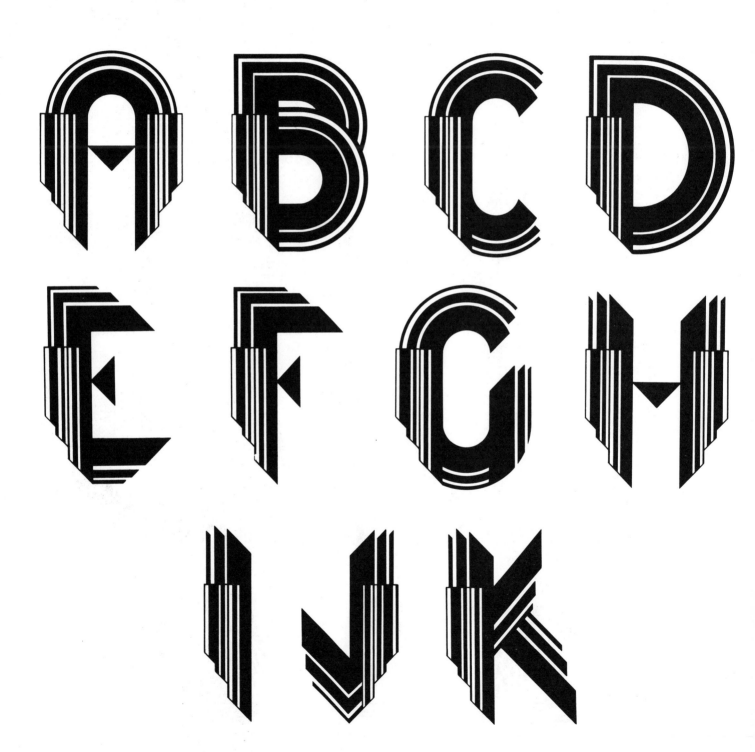

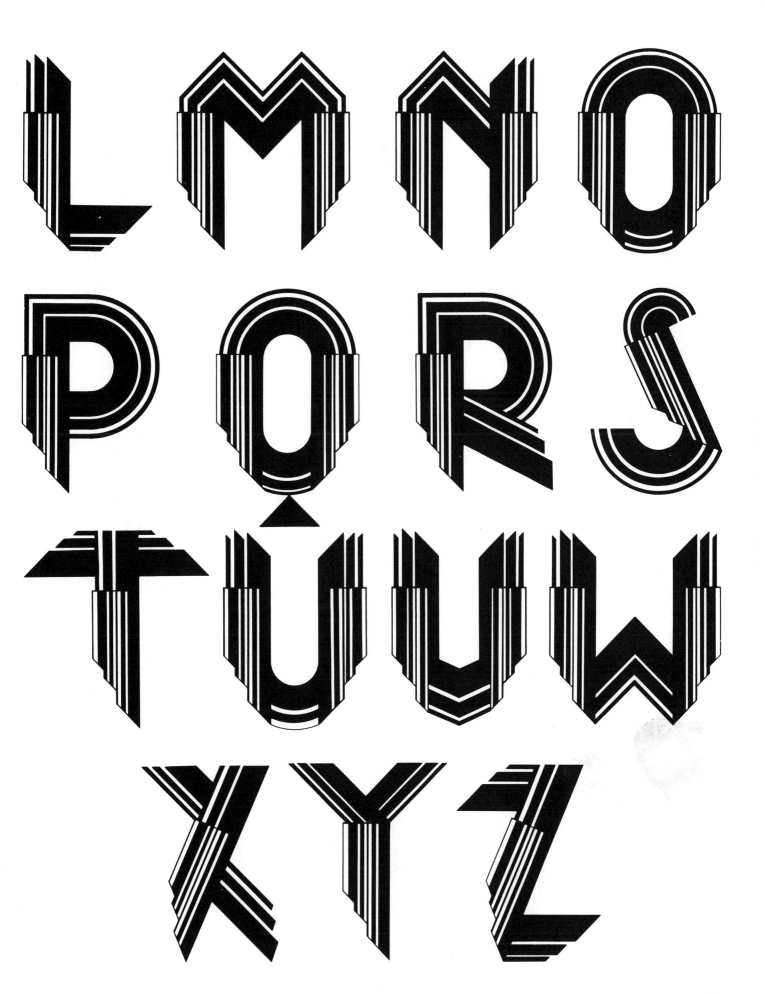

ABCDE
KLMN
STUV

WALDORF

F G G H N I I J
O O P Q Q R
W X Y Z

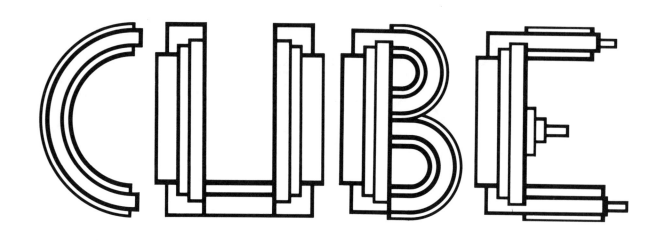

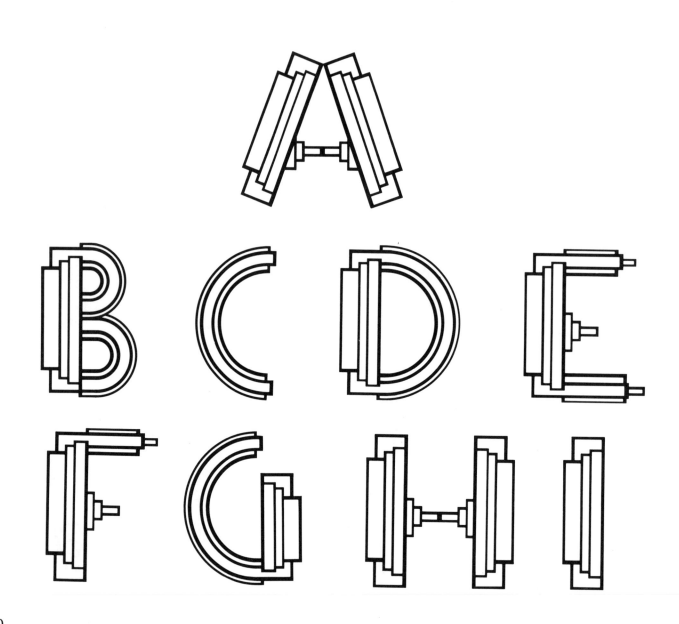

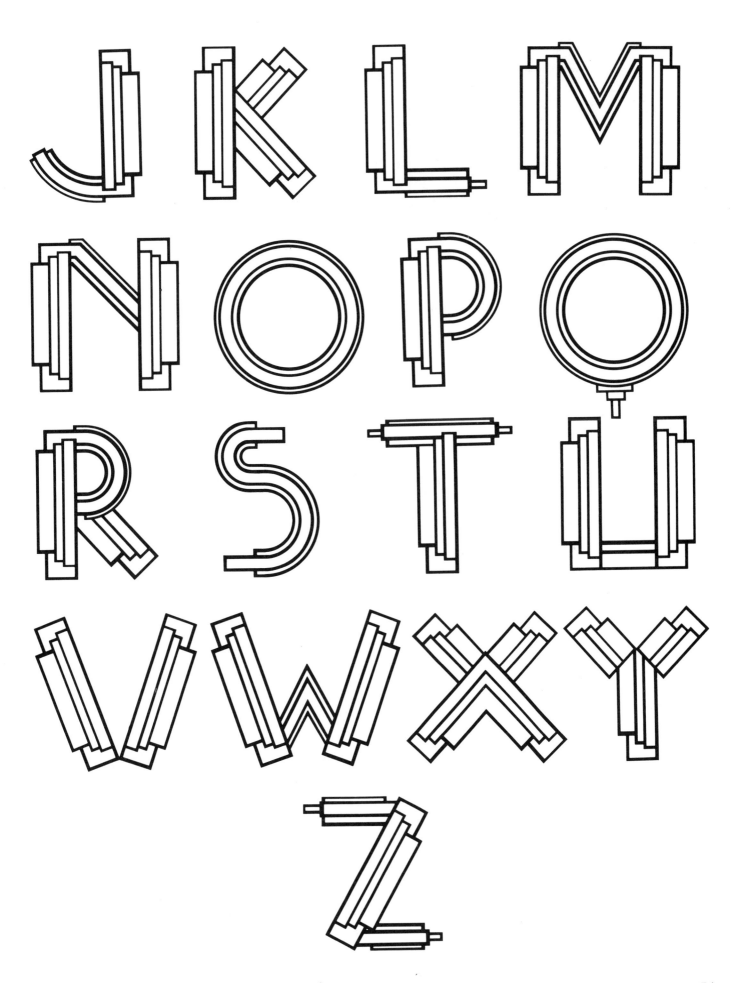

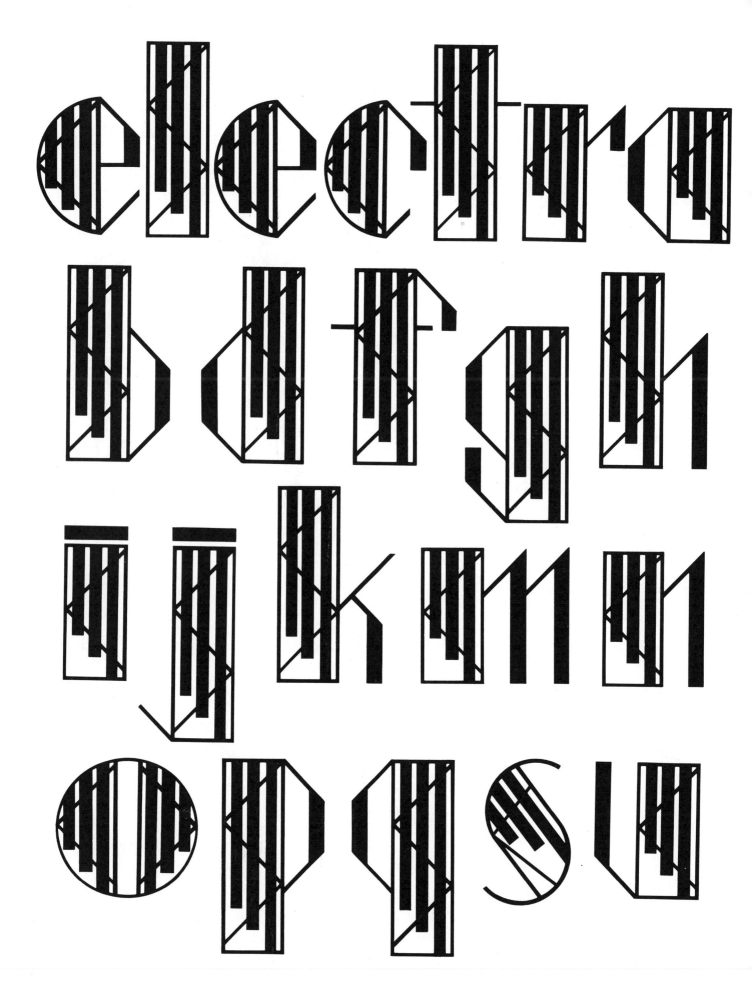

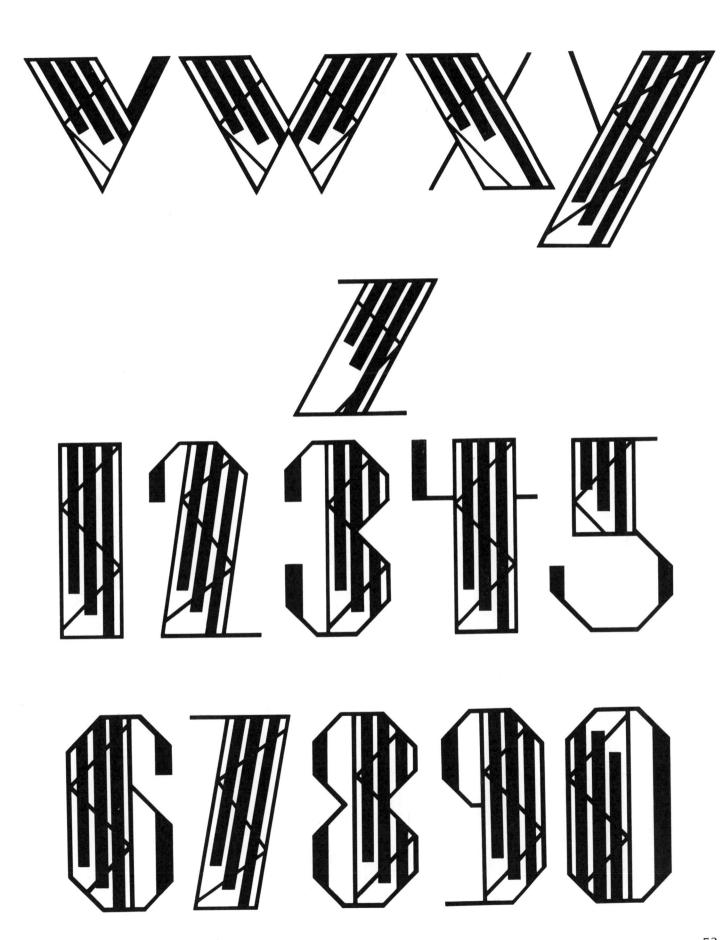

EMPIRE

ABC
DEFG
HIJK

LMNO
PQRS
TUVW
XYZ

N O P
Q R S T
U V W X
Y Z

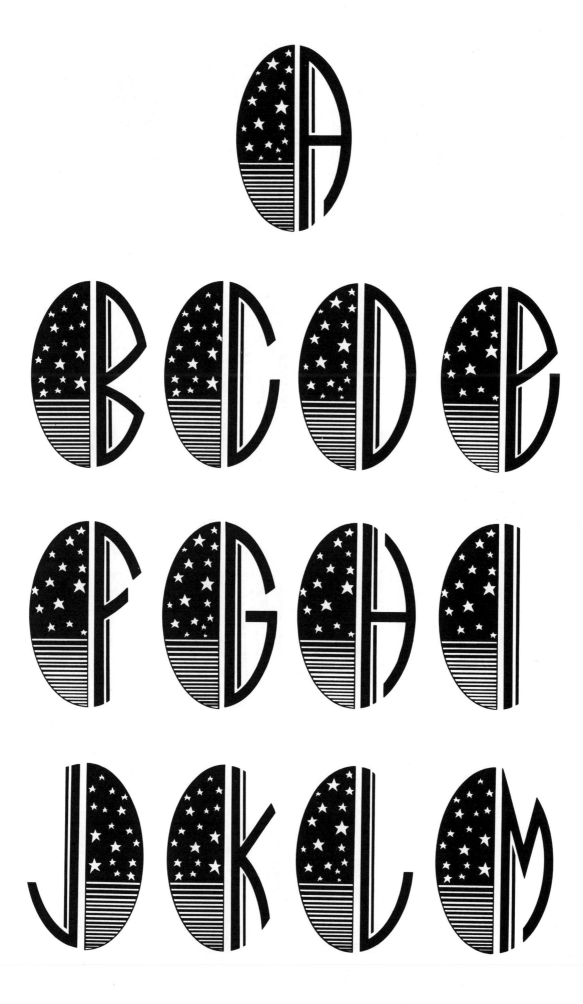

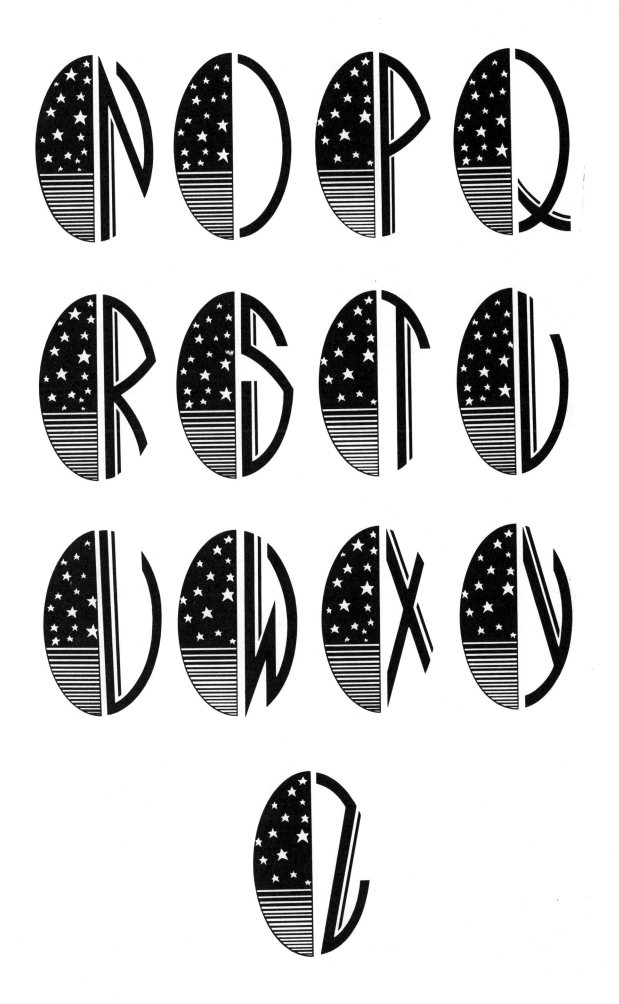

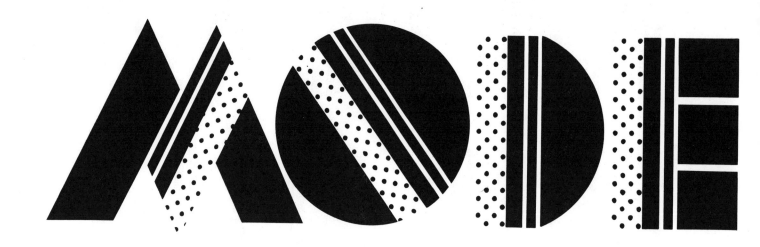

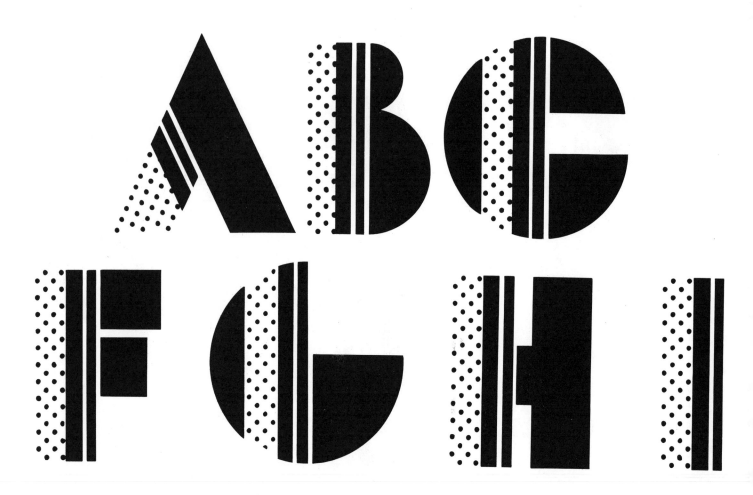

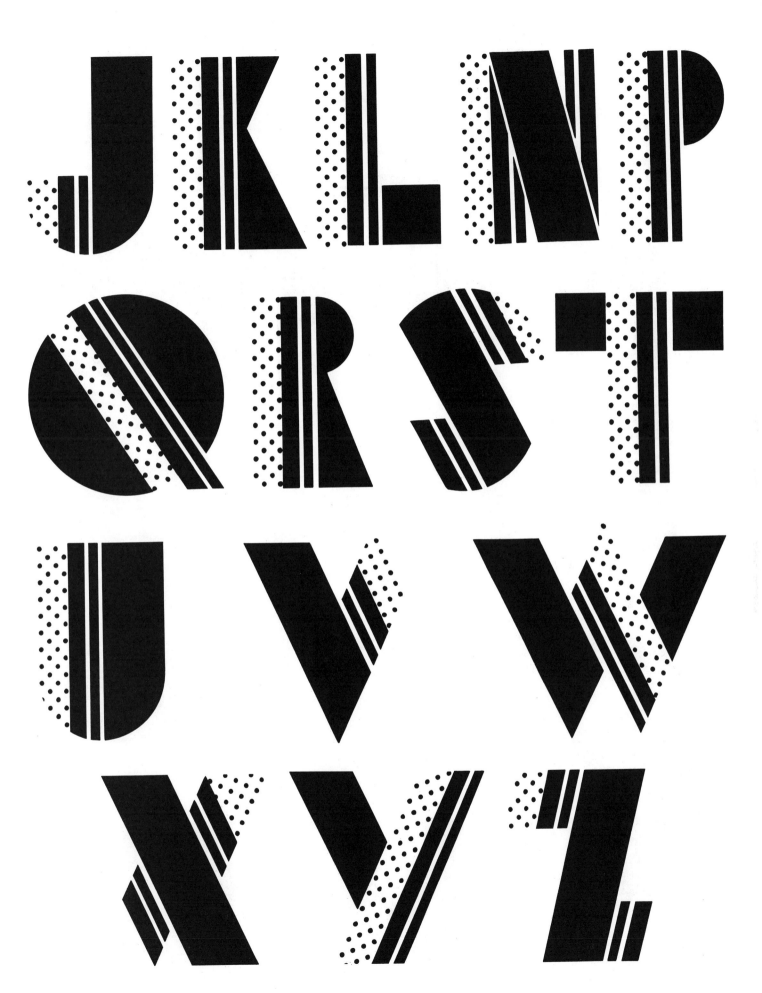

abcde
fghijk
lmnop
qrstu
vwxyz

ebony

12345
6789

REFLEX

ABC

DGH

IJK

64

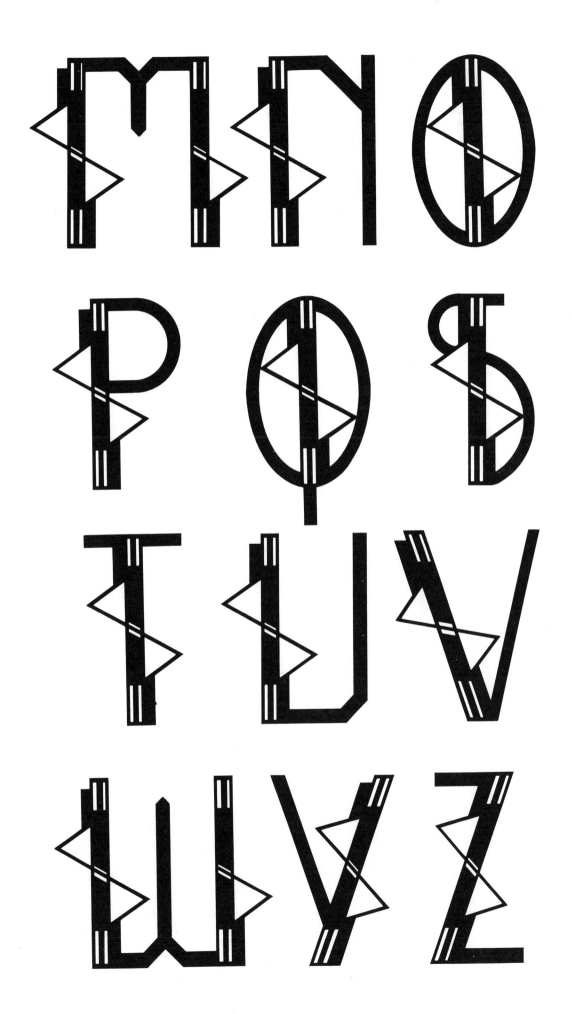

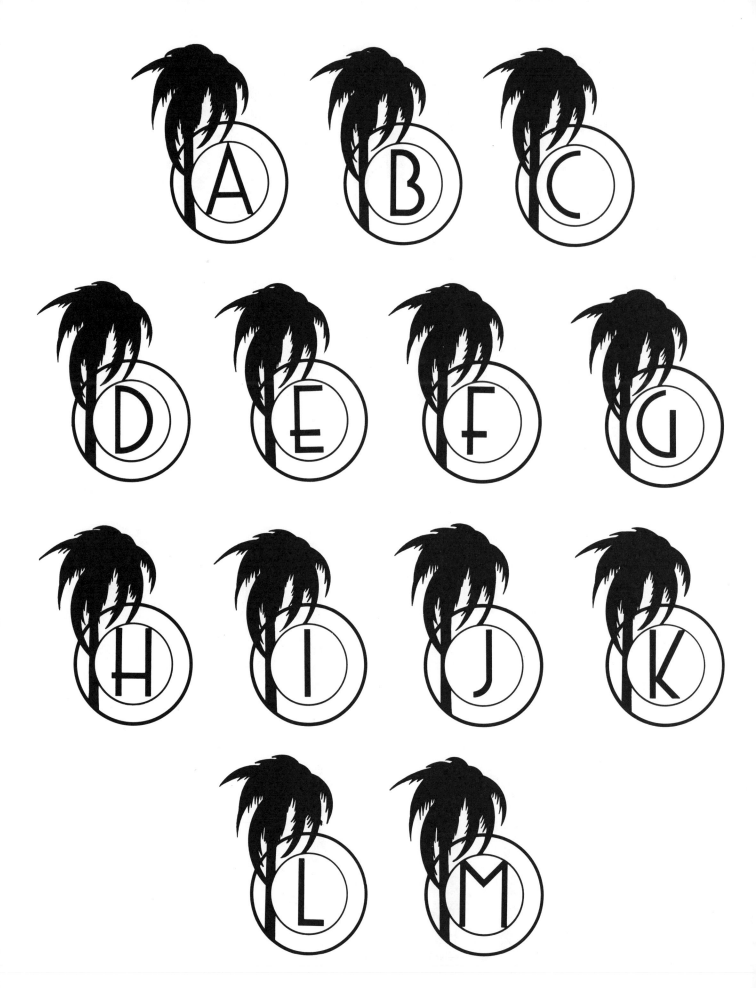

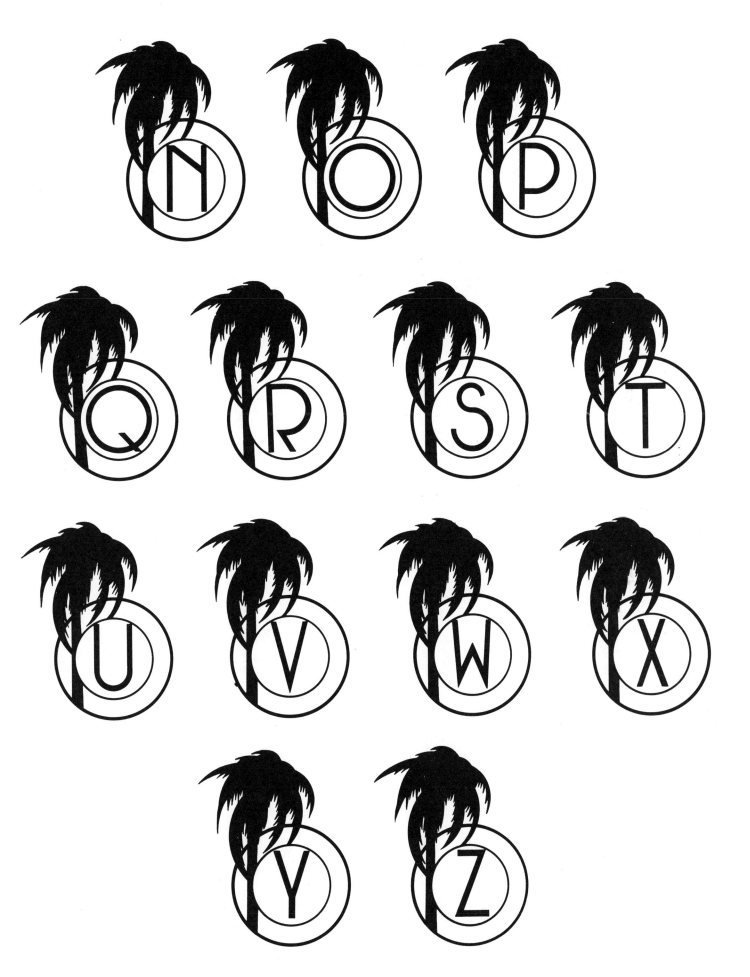

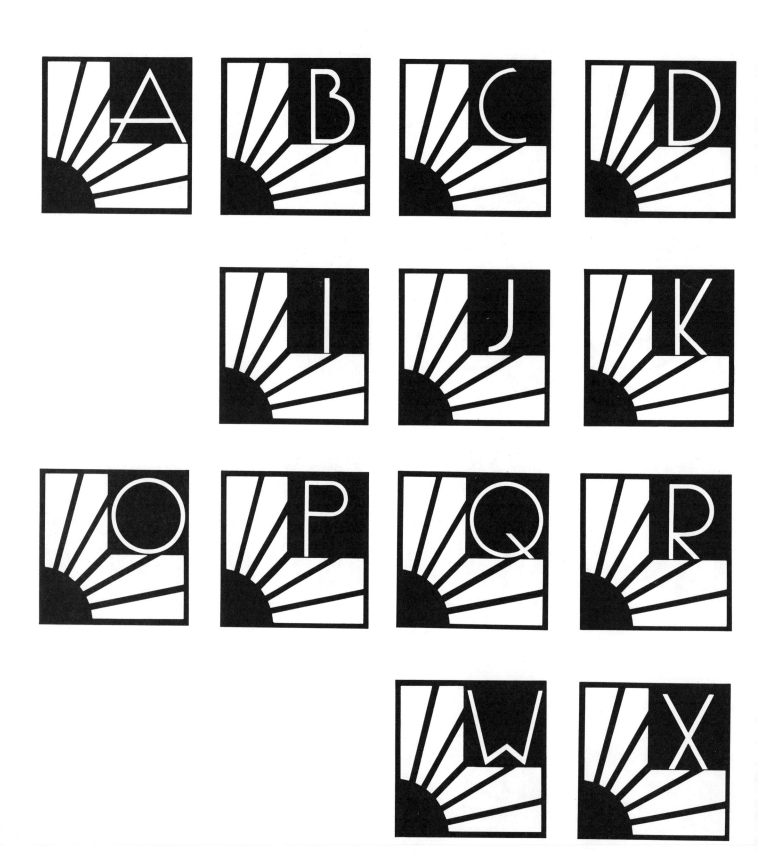

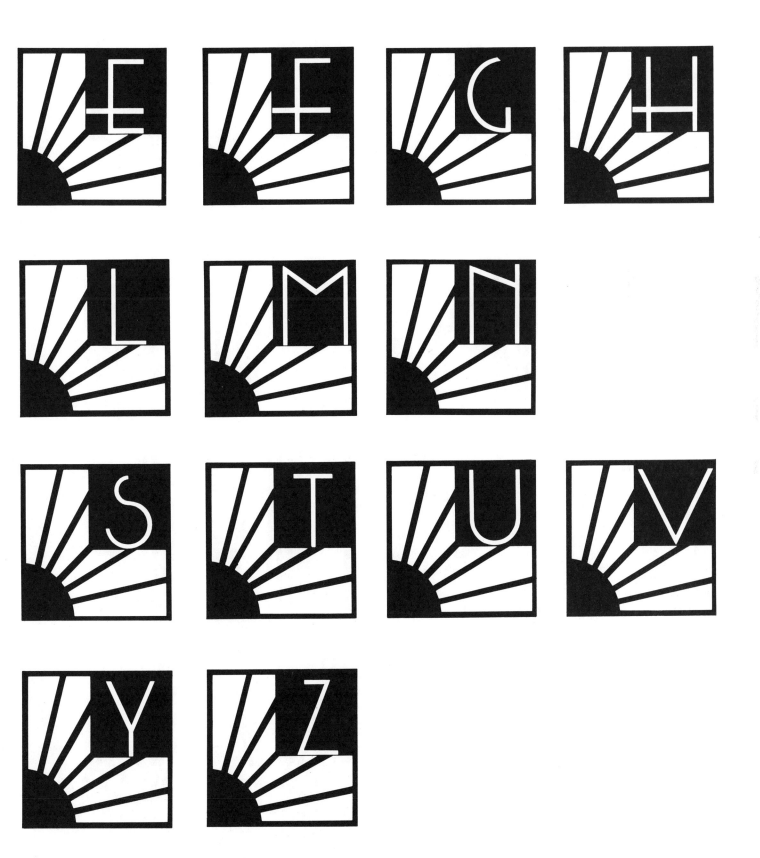

RAIN

A B C C D E E

K L M N N O

U V W

70

BCDW
FGHIJ
PQRST
XYZ

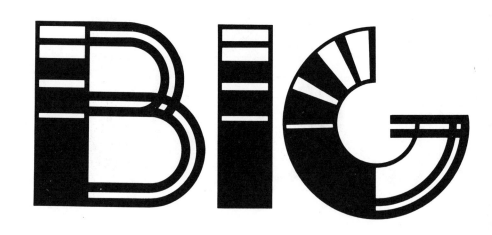

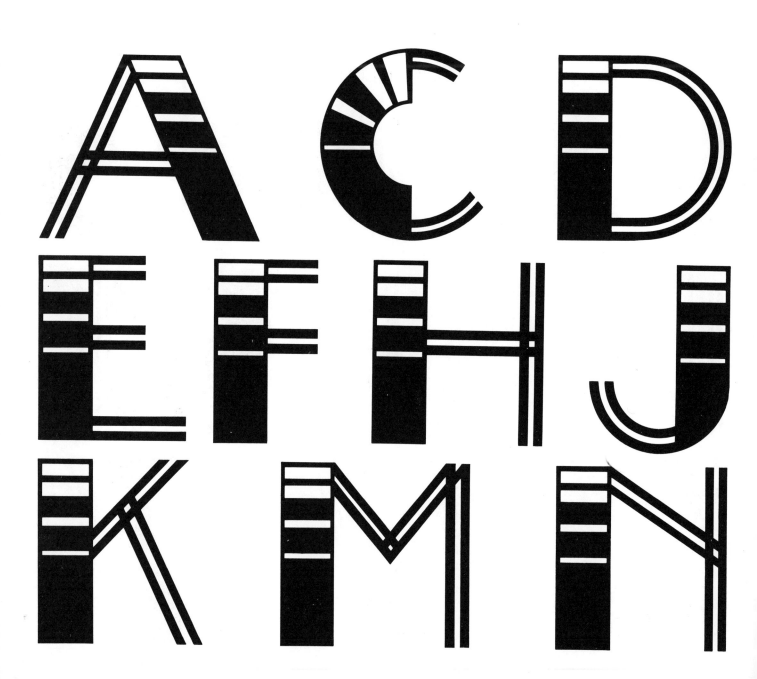

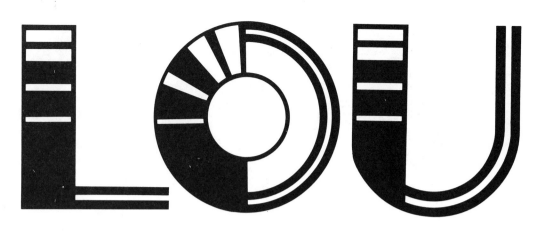

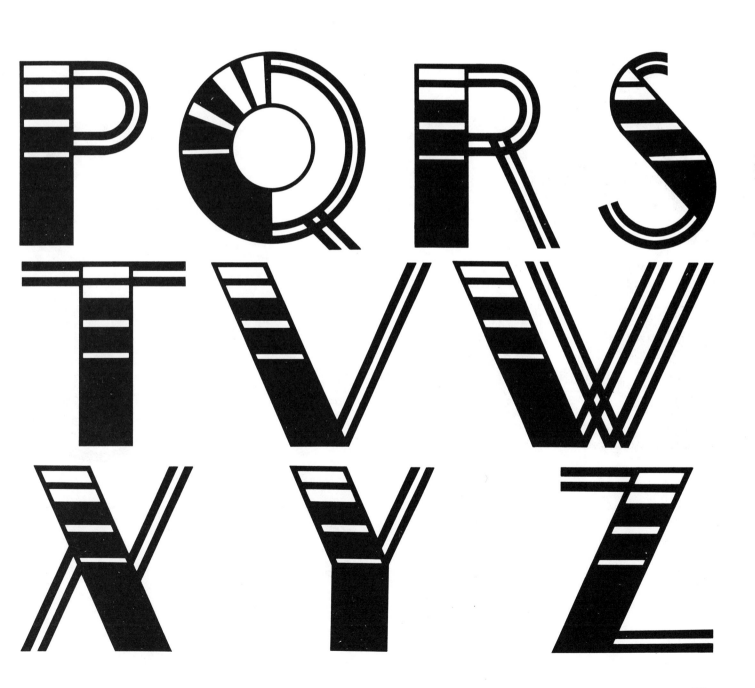

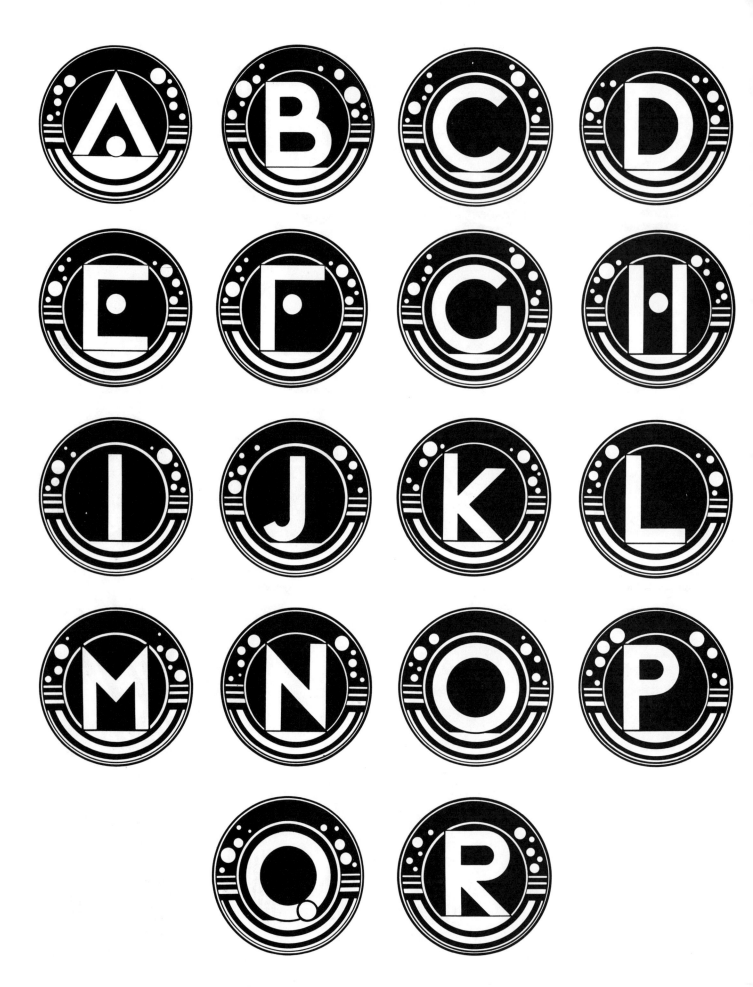

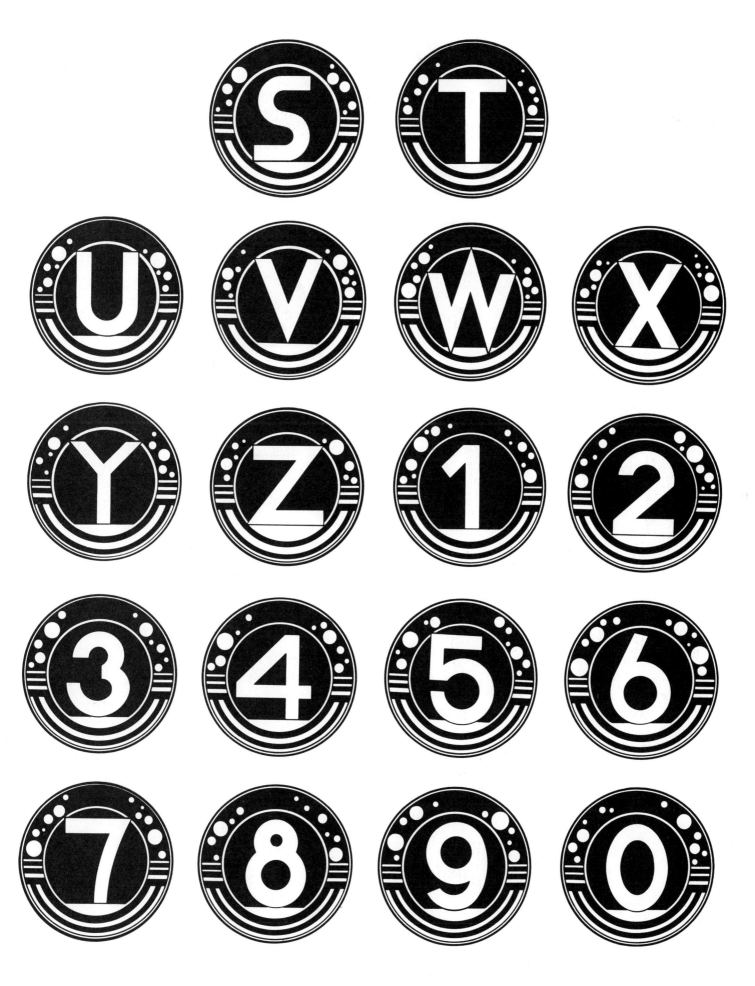